CUT, PASTE, CREATE

For Rachel

FRANCES LINCOLN

THIS BOOK BELONGS TO

--

--

€ collage your name HERE

Collage YOURSELF in a completely MISMATCHED outfit

CUT, PASTE, CREA

PROJECTs for yo

design

Complete th

way that suits y

Use the space ;

CREATE and discov

STYL

projects i

at a pace th

ABOVE AL

ntains fifty-two
 make your own
OURNAL.
tivities in a
 the DESIGNER.
xPLORE how you
our OWN unique
espond to the
y order, and
orks for you.
NJOY!

COLLAGE tips

If you can't find a specific OBJECT, try splicing together lots of different IMAGES to make something unique

Make your own TEXTURES using paint, pencils, ink...ANYTHING. Let them dry, then cut shapes out of them.

Sometimes the scraps left behind after your cut out an object are MORE interesting than the original item. KEEP them in an envelope for later.

Use a strong GLUESTICK and keep your blade sharp if using a CRAFT KNIFE.

COLLECT as much material as possible. Things around the house such as ENVELOPES or old NEWSPAPERS can provide inspiration.

SIMPLE can be best. If you're stuck for ideas, start with a geometric shape and build up more DETAILED layers.

BE THE DESIGNER! This is your space to be CREATIVE!

WELCOME
people to your
HOME

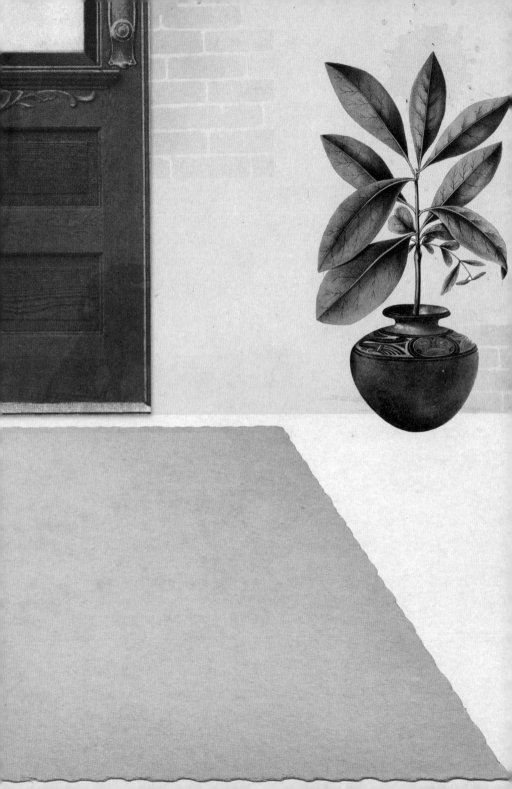

Build a
TREEHOUSE

Design your own
BOOKENDS

If you could change your HAIRSTYLE every day, what would it look like?

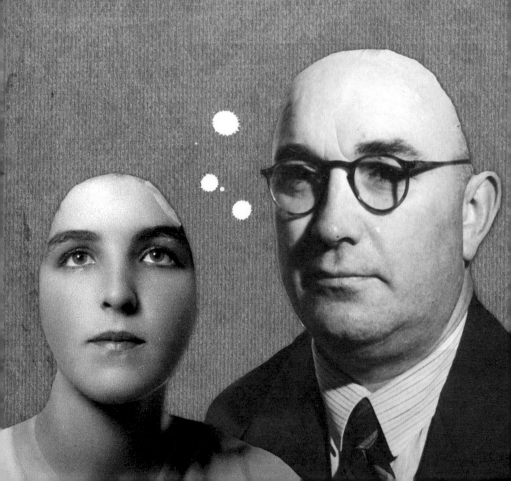

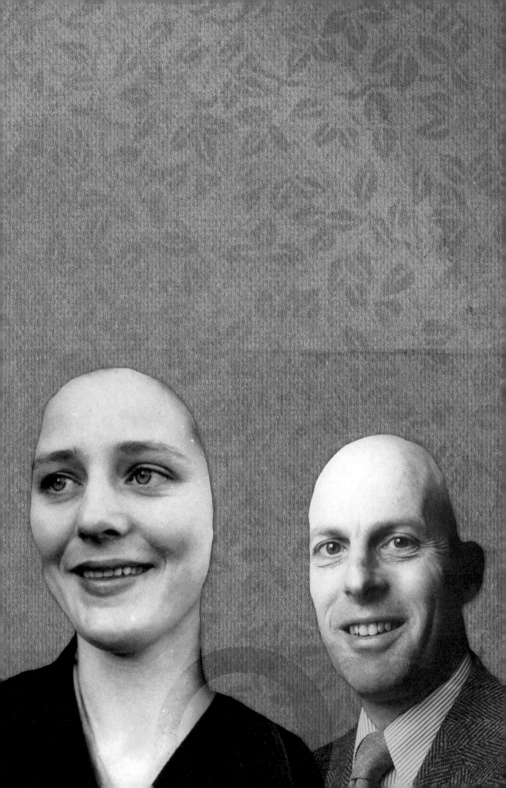

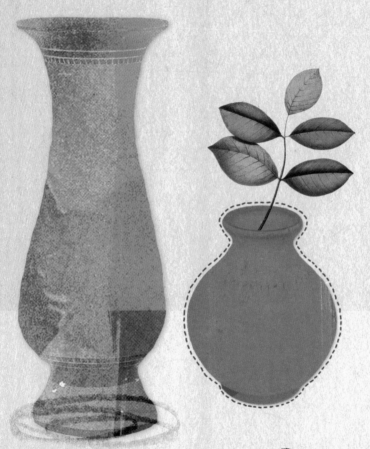

Become the creator of your own CERAMICS range
(collage plants into them!)

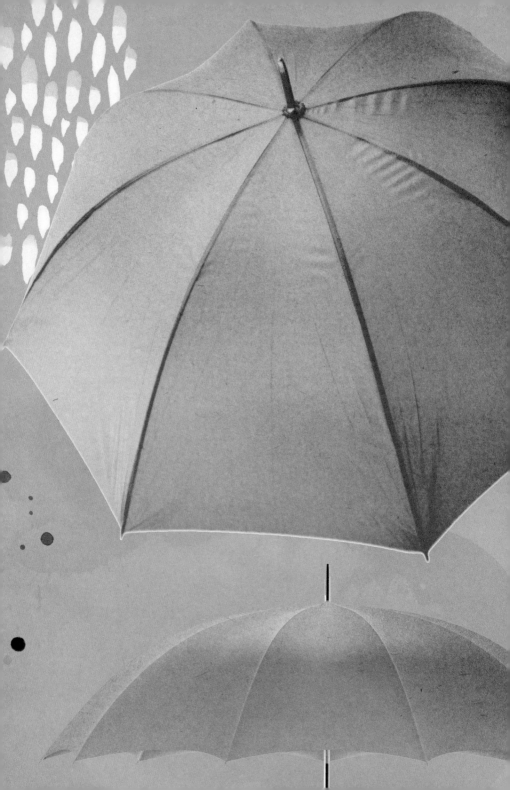

Design some cheery UMBRELLAS for when you're under the weather

Make CUSHIONS to fill the SOFA

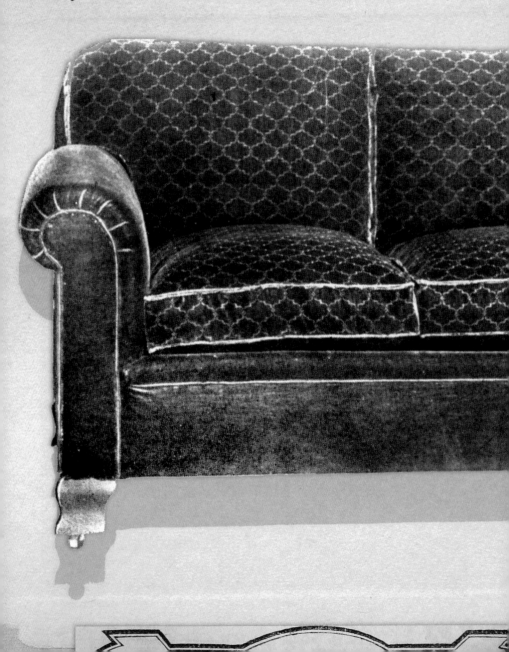

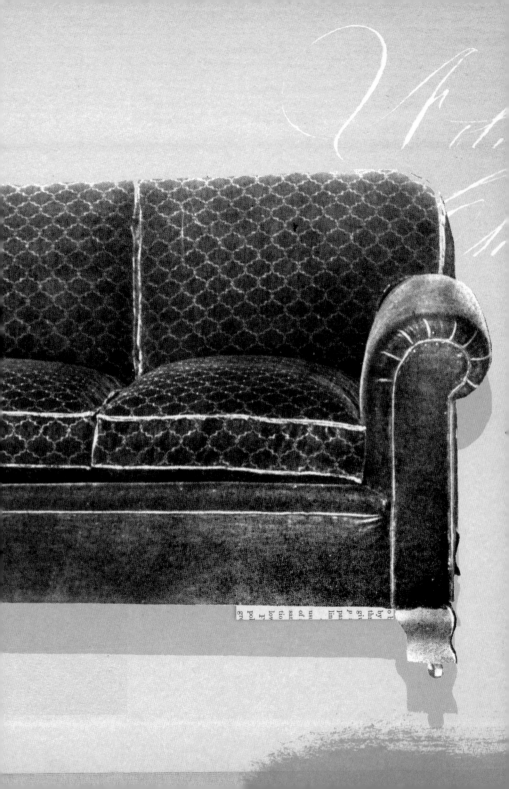

Collage designs for your own
SPRING fashion COLLECTION

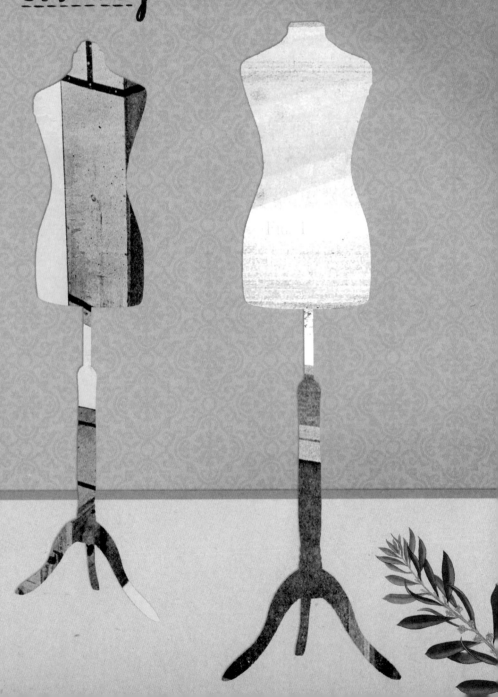

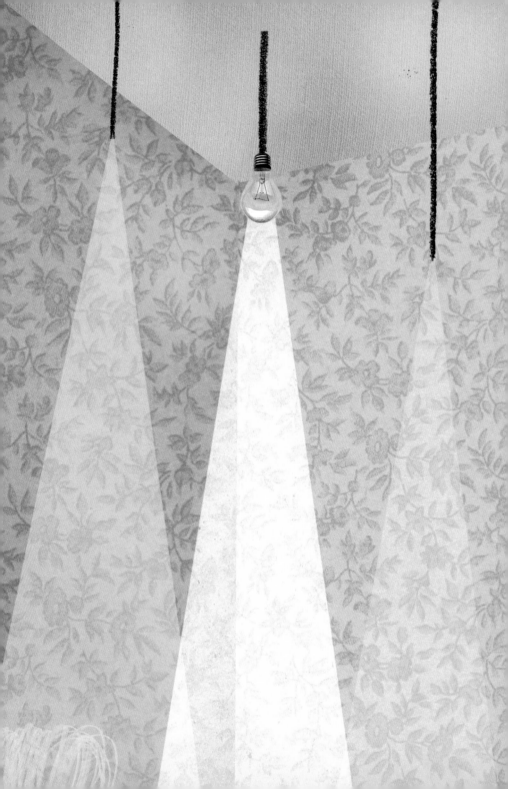

Design your own collection of
LIGHTSHADES

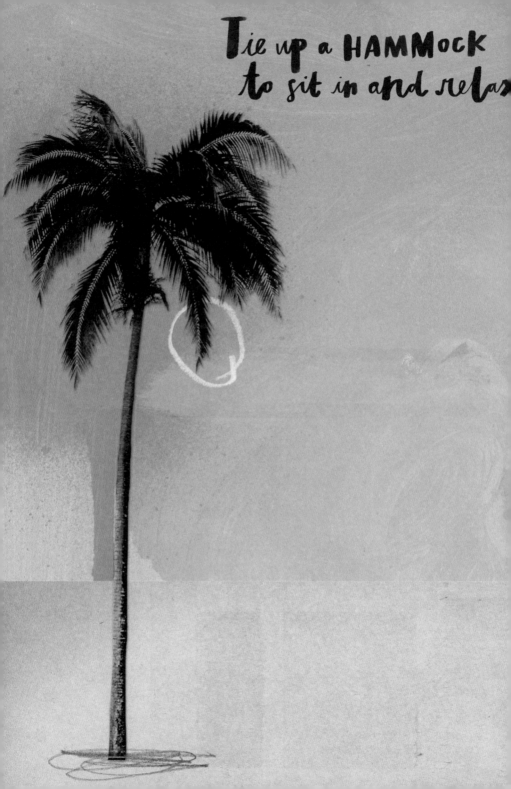

Tie up a **HAMMOCK**
to sit in and relax

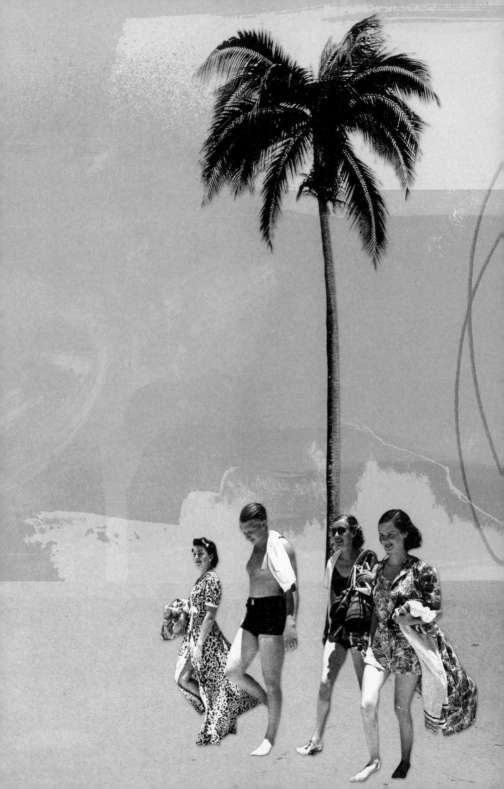

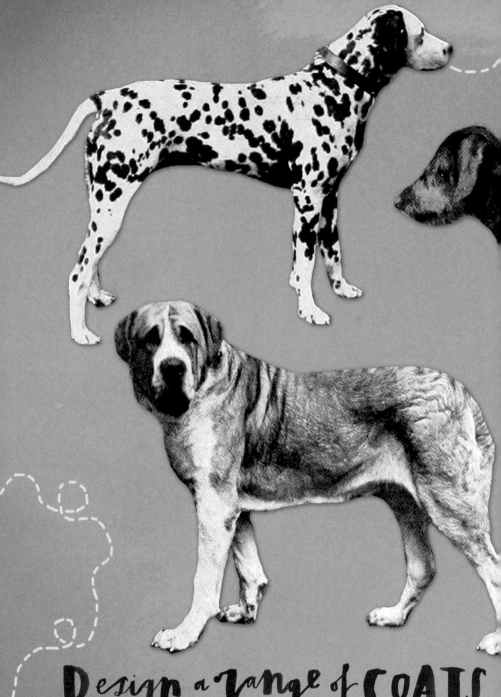

Design a range of COATS for your DOG

WOOF!

Create some TRIBAL headwear

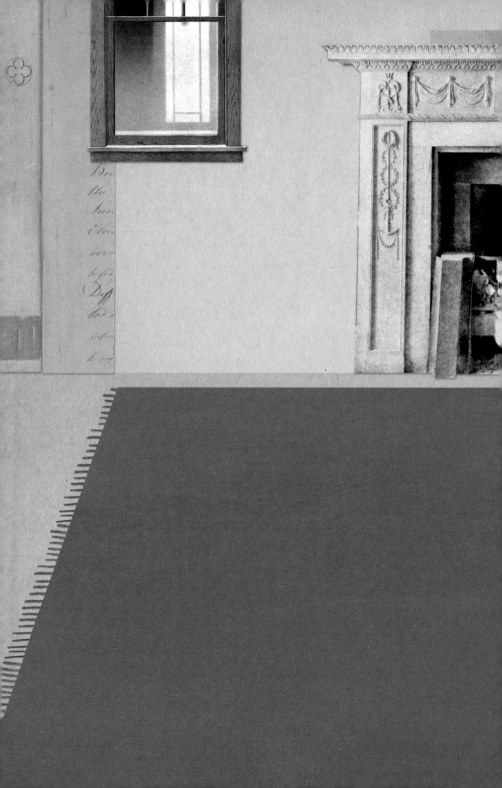

Design a **RUG**

Fill the sticky notes with INVENTIONS and IDEAS (think outside the Box)

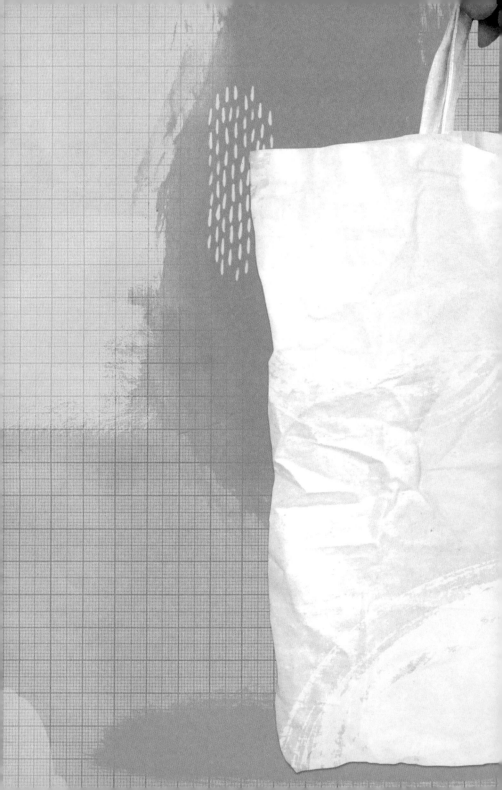

Fill the BAG with PATCHES and BADGES that are personal to you

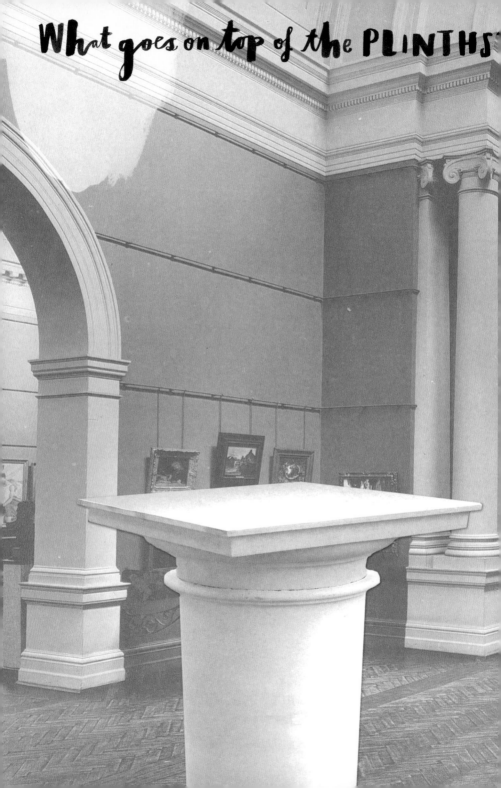

What goes on *top of* the PLINTHS

CREATE your dream HOME

Create a new CANVAS
for the DECKCHAIR

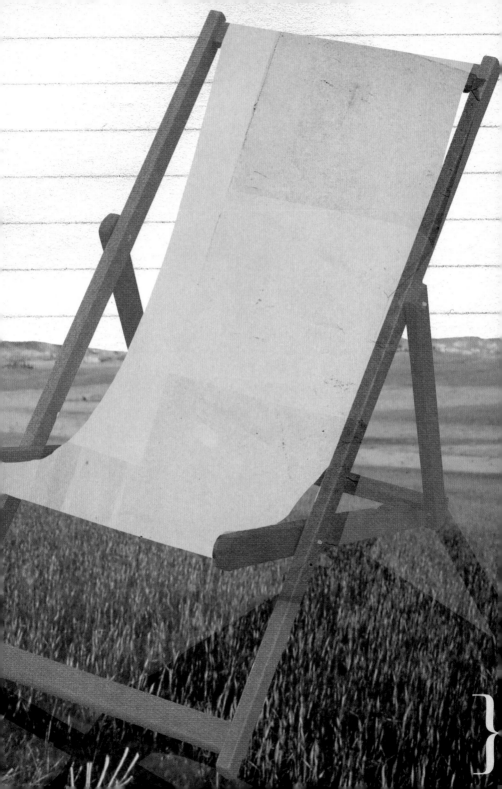

Collage designs for your own
SUMMER fashion COLLECTION

Fill the TEA TRAY ready for

a visit from a friend

Collage your own WALLPAPER

Design your own CURRENCY

Cover the FRIDG

reflect you

ith things that
ERYDAY life

Create a set of
SALT and PEPPER shakers

Add interesting HANDLES onto
the chest of drawers

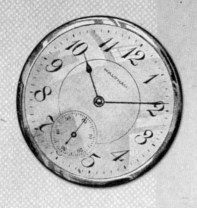

A ttach different STRAPS to the WATCHES

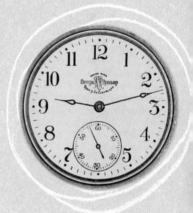

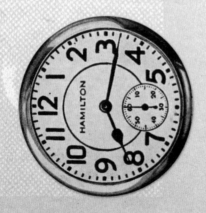

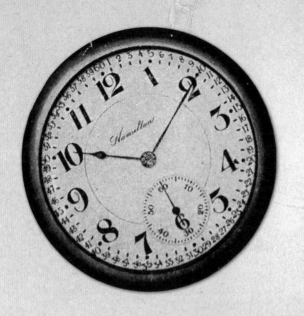

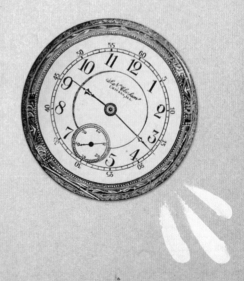

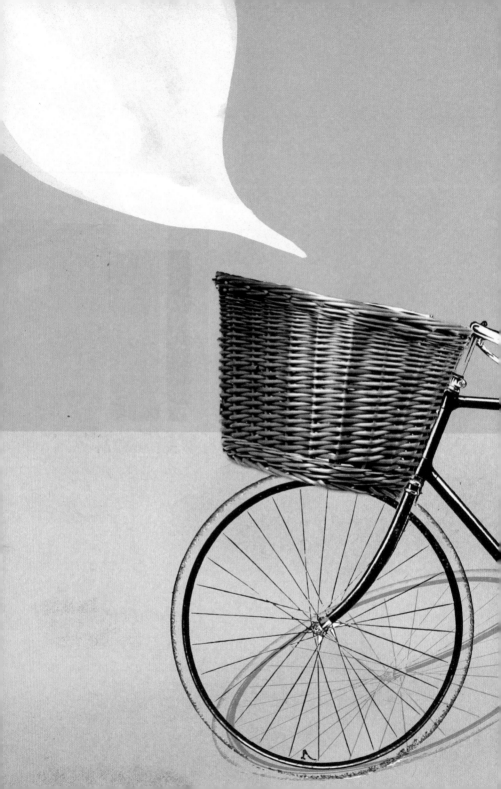

Fill the BIKE basket

THE PRESENT DAY CYCLE

Design a STAINED GLASS WINDOW

Collage designs for your own AUTUMN fashion COLLECTION

Fig. 1

Fig.

Create a
Book Cover
for a
CLASSIC
novel

Fill the kitchen wall with unique TILES

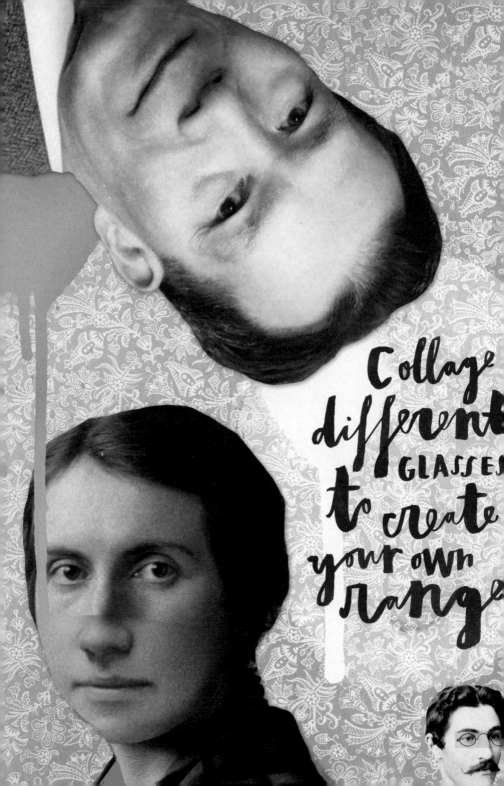

Collage different GLASSES to create your own range

Collage a unique

CLOCKFACE

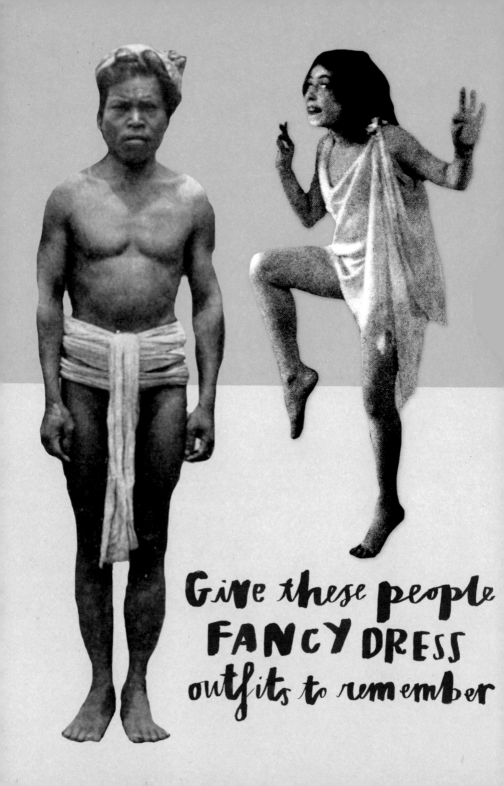

Give these people
FANCY DRESS
outfits to remember

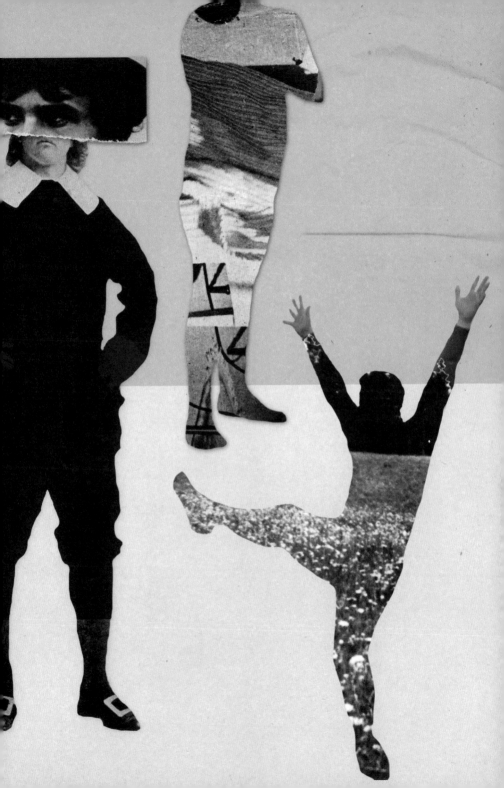

Produce your own piece of ABSTRACT ART

Design a KITE

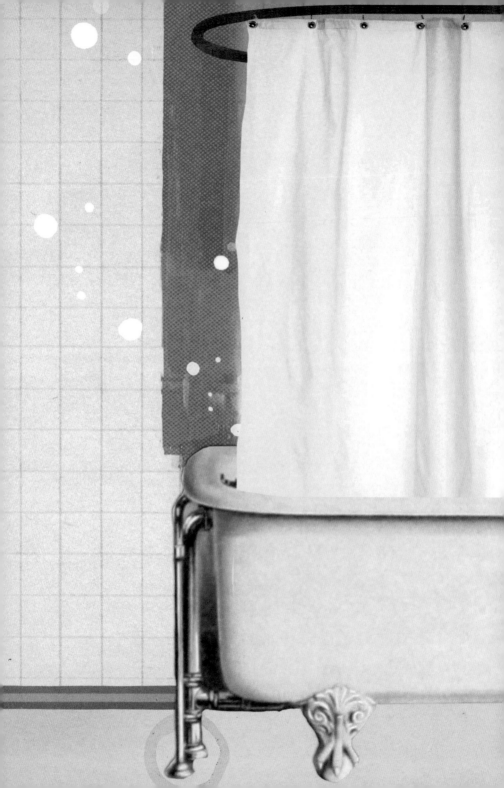

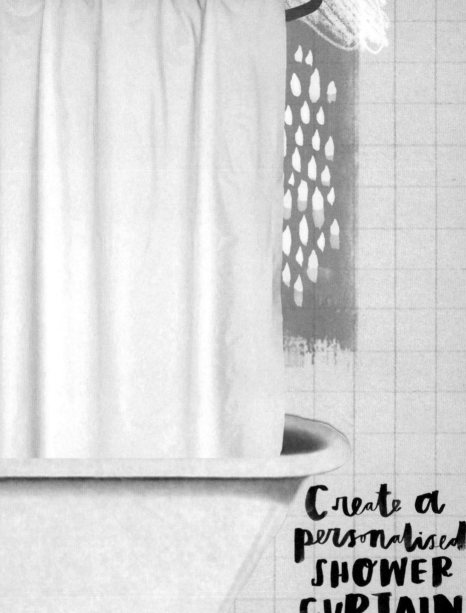

Create a
personalised
SHOWER
CURTAIN

Fill the SHELVES with interesting objects

9

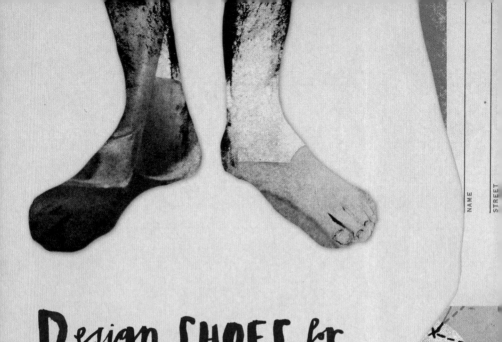

Design SHOES for different occasions

and dependability. They must also be
engineered into the smallest, lightest an
most compact form possible. Helping
meet this and other engineering challen
is a history of engineering achievement
which includes, after one quarter million
the world's most accurate gyroscopes
more flight control system
company has produce

76

09

82⁷⁰

Collage designs for your own
WINTER fashion COLLECTION

FIG. 2

Fig. 2

Design
a new cover
for your
favourite
ALBUM

Attach LUGGAGE LABELS to the bags and cases

Design your perfect CHAIR

Collage PATTERNS onto the TIES to suit different MOODS

Design a
POSTER for your
favourite FILM

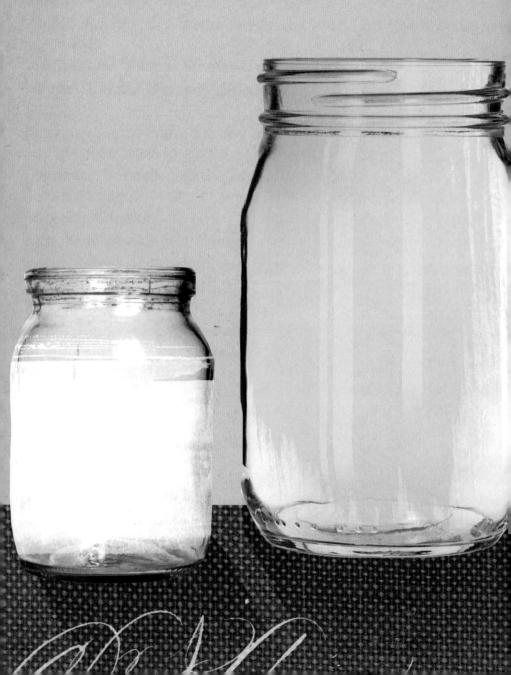

Make LABELS for the JARS

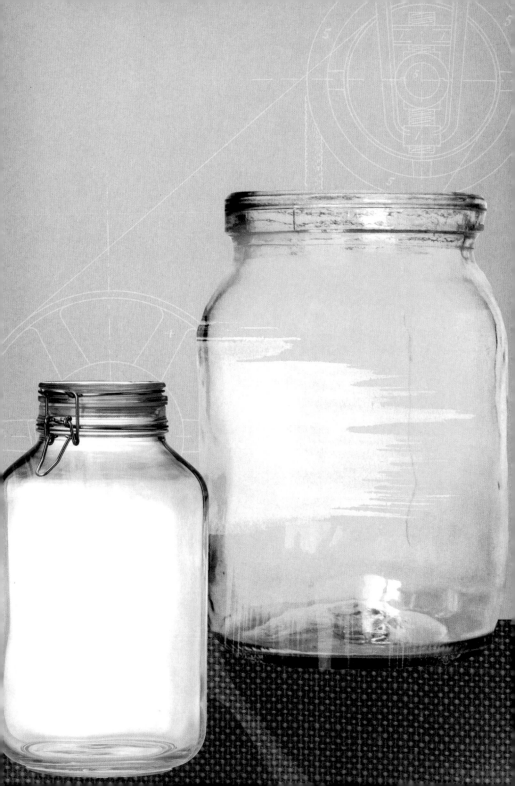

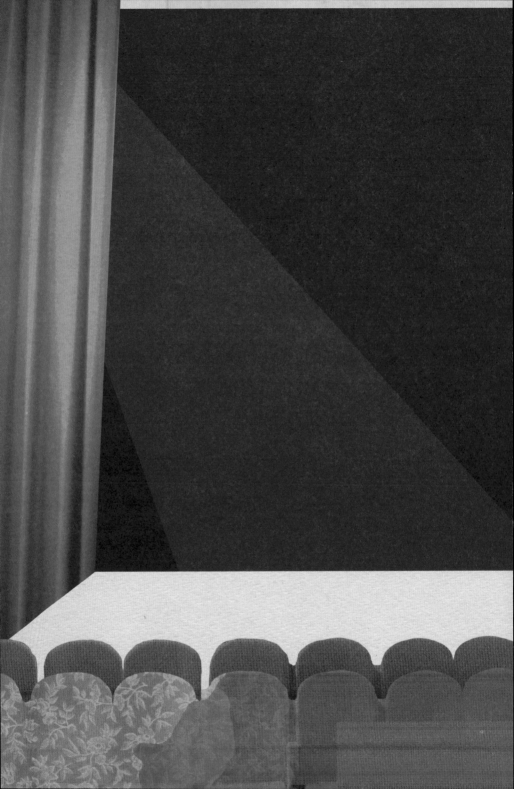

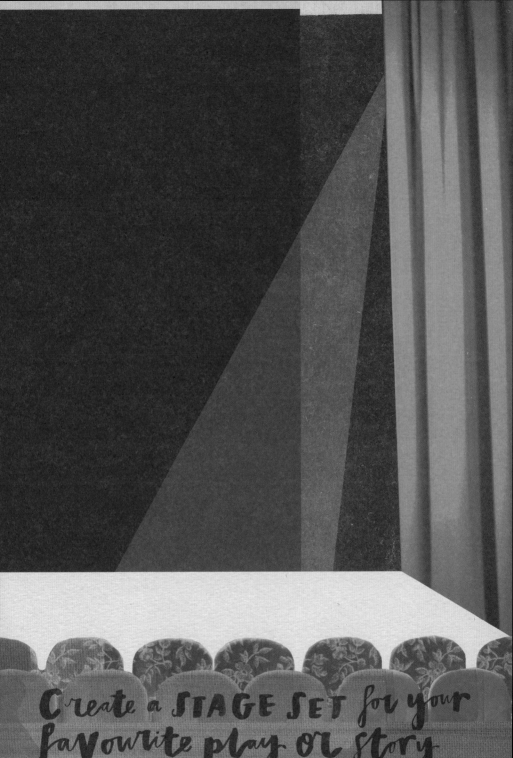

Create a **STAGE SET** for your favourite play or story

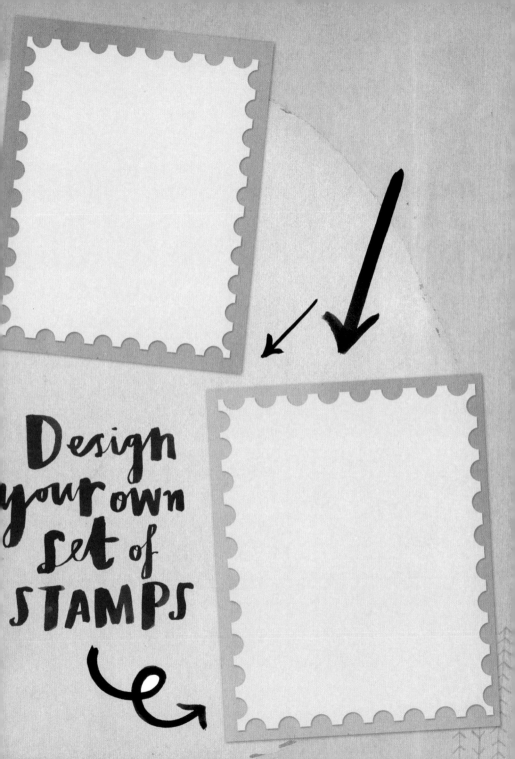

Design your own set of STAMPS

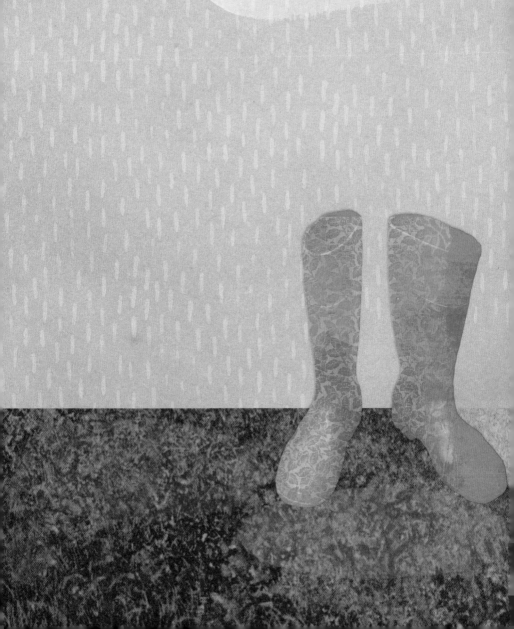

Make designer WELLIES to brighten up a rainy day

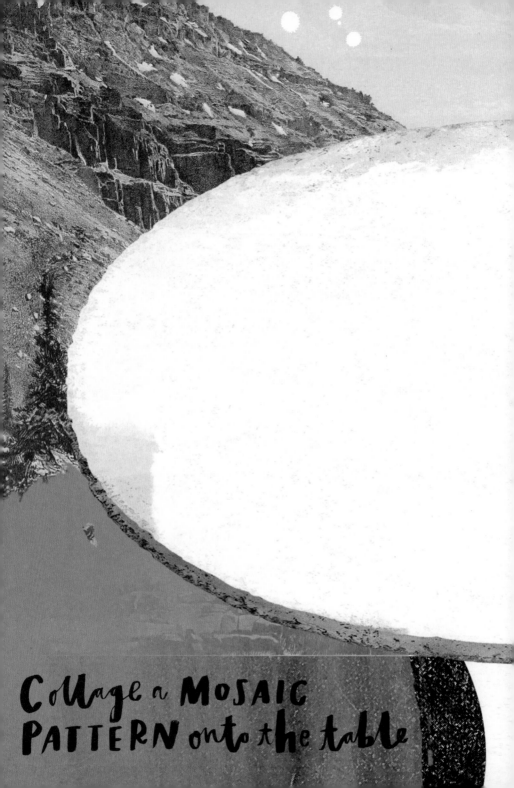

Collage a MOSAIC PATTERN onto the table

Create handles for the
KITCHEN UTENSILS

GO BACK TO THE DRAWING BOARD

BIG THUMBS UP To.

Mum and Dad, James and Olivia
All the family and all the friends
Nicki and the FRANCES LINCOLN team
EMILY
Brittany
Eleanor Joy
My agent Suresh
DUNCAN, Alex, ABBIE, and
my friends at GREENSHAW
All who bought and encouraged COLLAGE and KEE